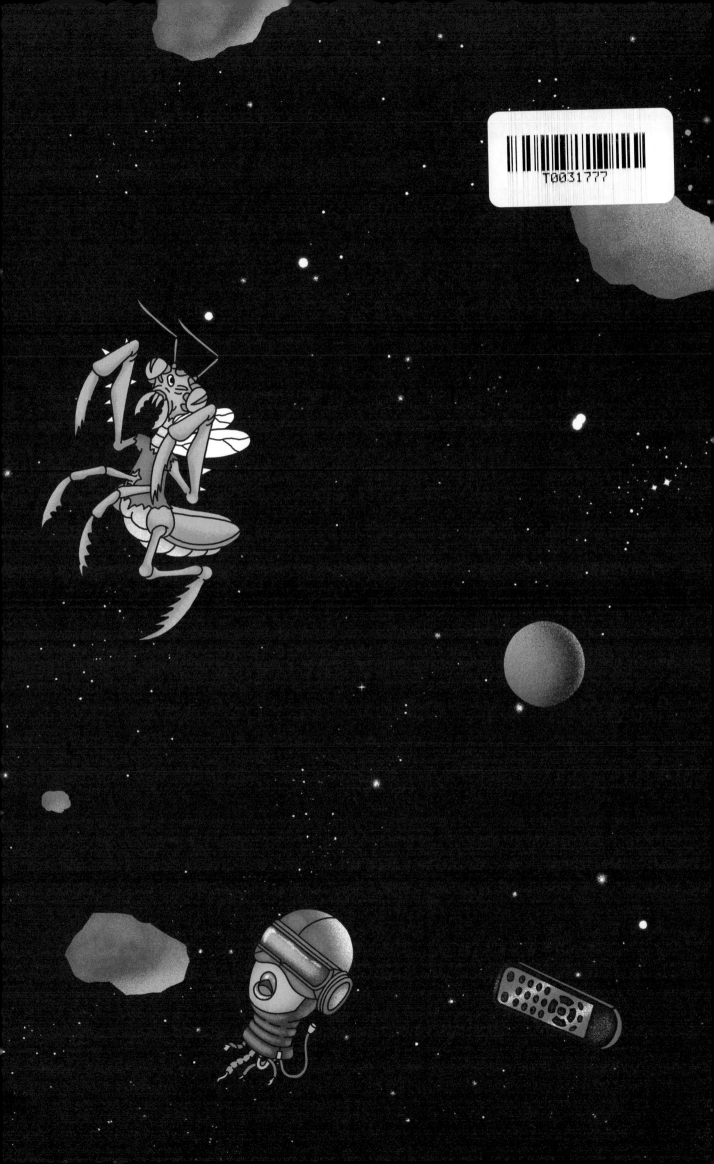

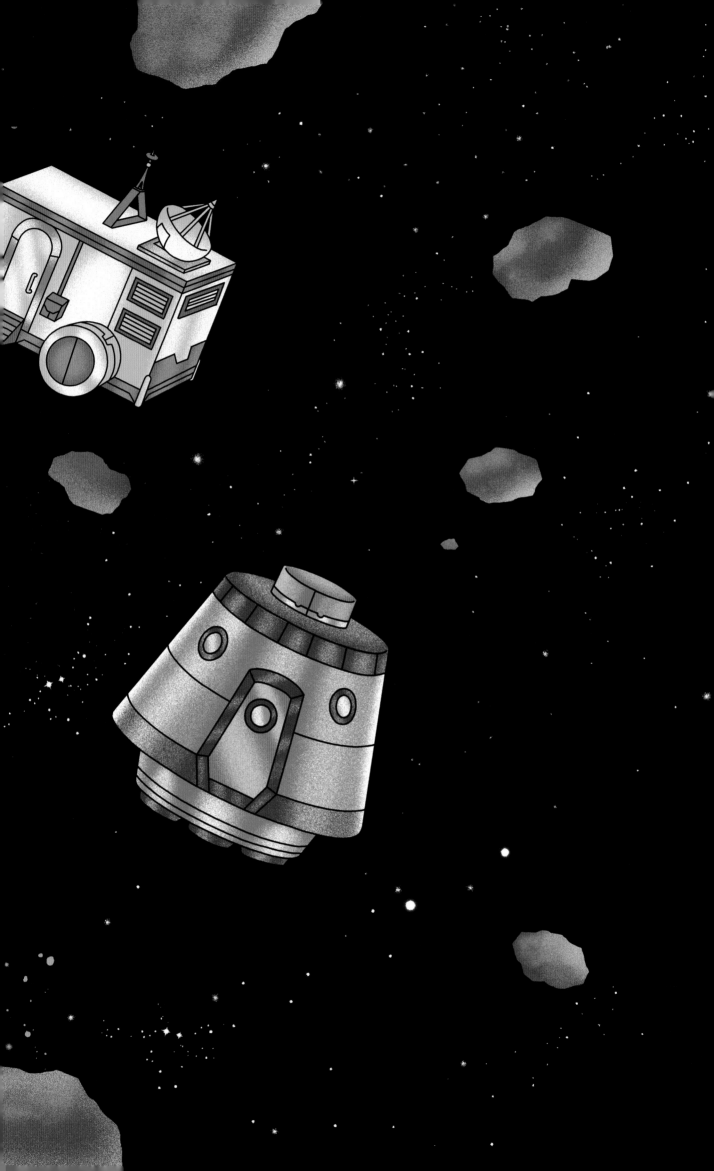

Rick and Morty

Seek 'N' Find

ILLUSTRATED BY

Josh Freydkis

DARK HORSE BOOKS

PRESIDENT AND PUBLISHER
MIKE RICHARDSON

EDITOR
IAN TUCKER

ASSOCIATE EDITOR
BRETT ISRAEL

ASSISTANT EDITOR
ANASTACIA FERRY

DESIGNER
SKYLER WEISSENFLUH

DIGITAL ART TECHNICIAN
JOSIE CHRISTENSEN

SPECIAL THANKS TO ELYSE SALAZAR, MEAGAN BIRNEY, AND BRANDON LIVELY
AT ADULT SWIM, AND JASON STRUSS AT WARNER BROS.

RICK AND MORTY: SEEK 'N' FIND

PUBLISHED BY DARK HORSE BOOKS
A DIVISION OF DARK HORSE COMICS LLC
10956 SE MAIN STREET
MILWAUKIE, OR 97222

DARKHORSE.COM
EBOOK ISBN 978-1-50671-905-4
HARDCOVER ISBN 978-1-50671-904-7
FIRST EDITION: JANUARY 2023

1 3 5 7 9 10 8 6 4 2
PRINTED IN CHINA

MIX
Paper from
responsible sources
FSC® C016973

FIND RICK, MORTY, AND THE REST OF THE SMITH FAMILY HIDDEN THROUGHOUT THE MULTIVERSE!

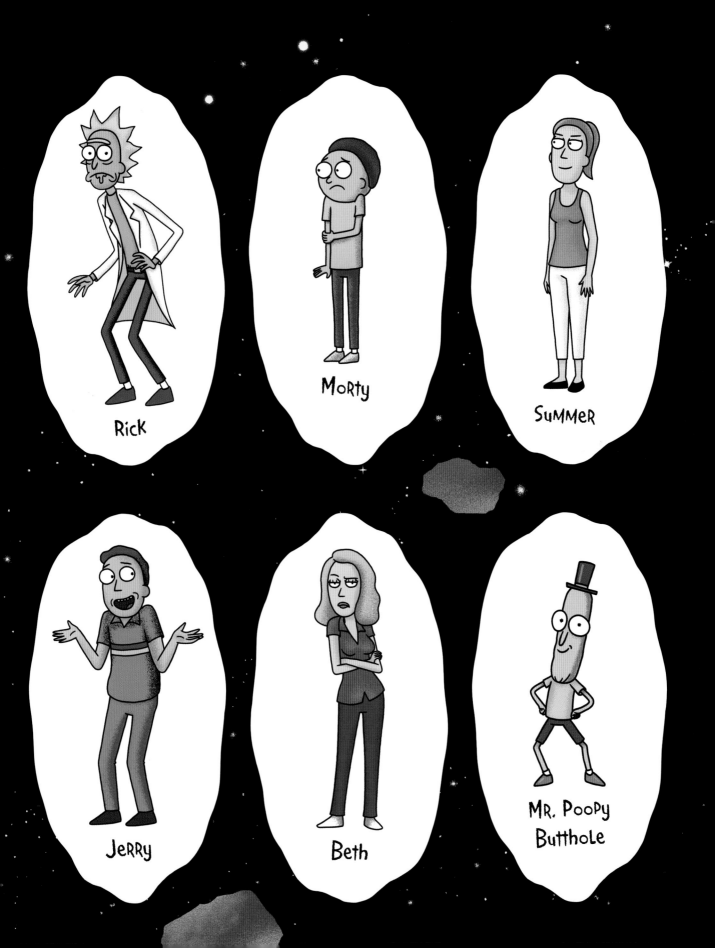

Rick

Morty

Summer

Jerry

Beth

Mr. Poopy Butthole

LOCATIONS

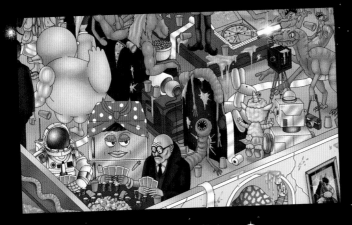

SMITH HOUSE

ANATOMY PARK

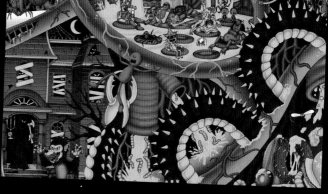

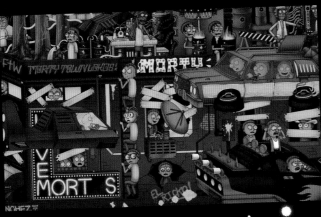

THE CITADEL

PLUMBUS FACTORY

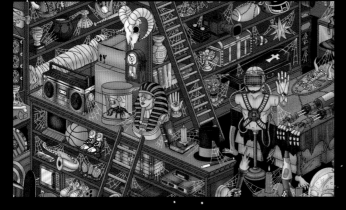

NEEDFUL THINGS

PSYCHEDELIA

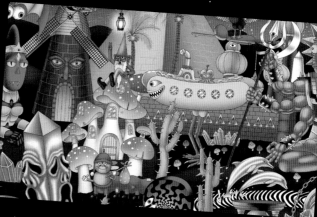

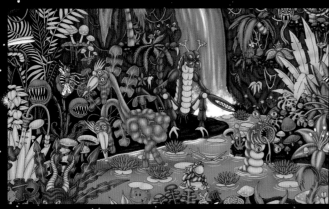

RICK'S POOP PLANET

BALTHROMAW'S LAIR

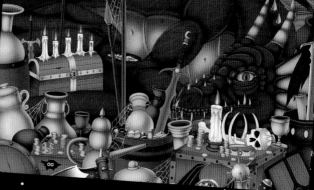

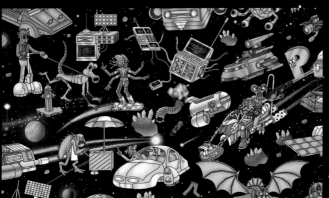

OUTER SPACE

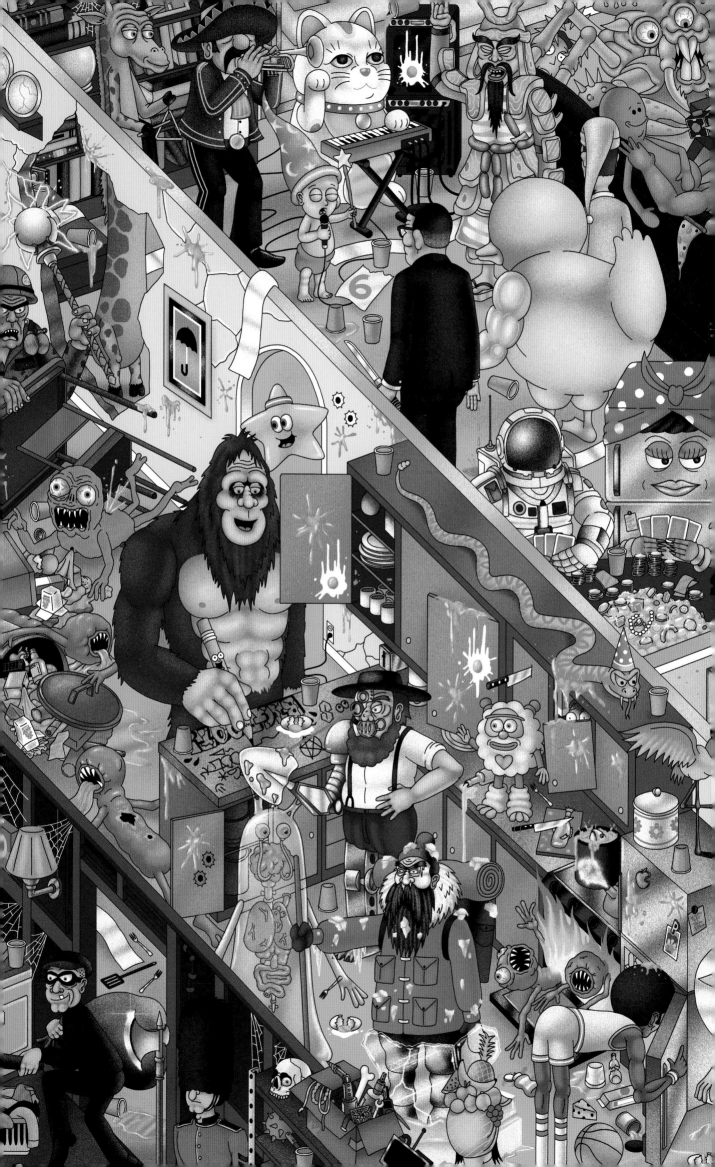

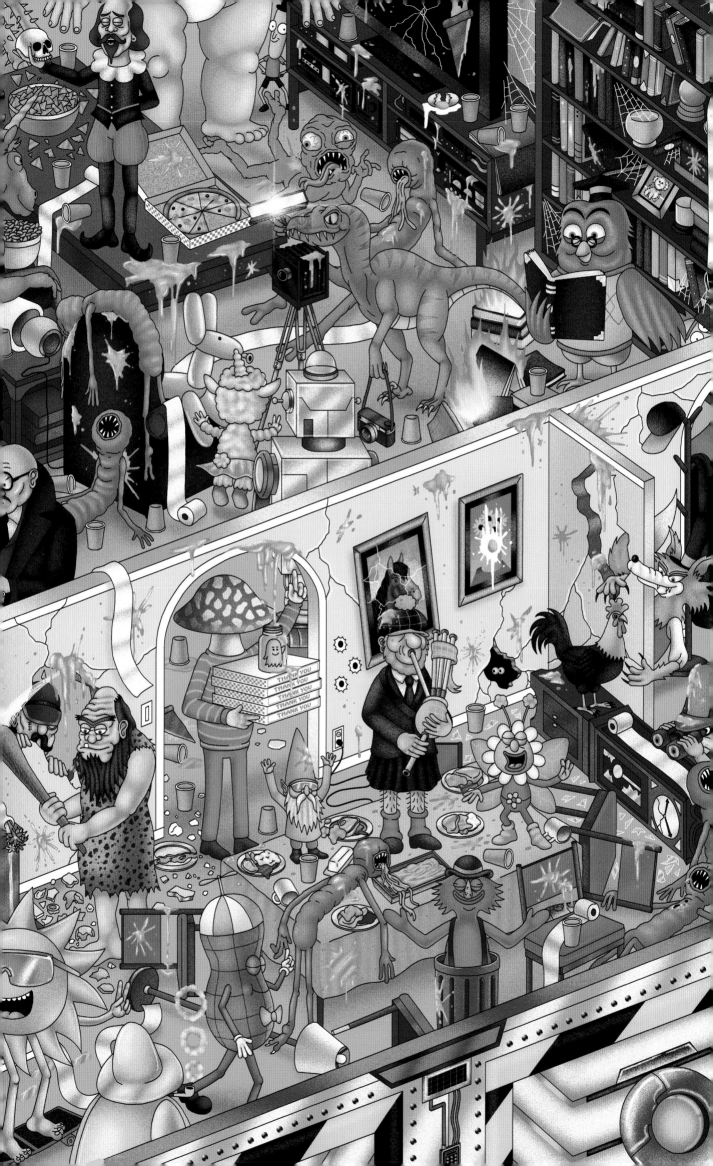

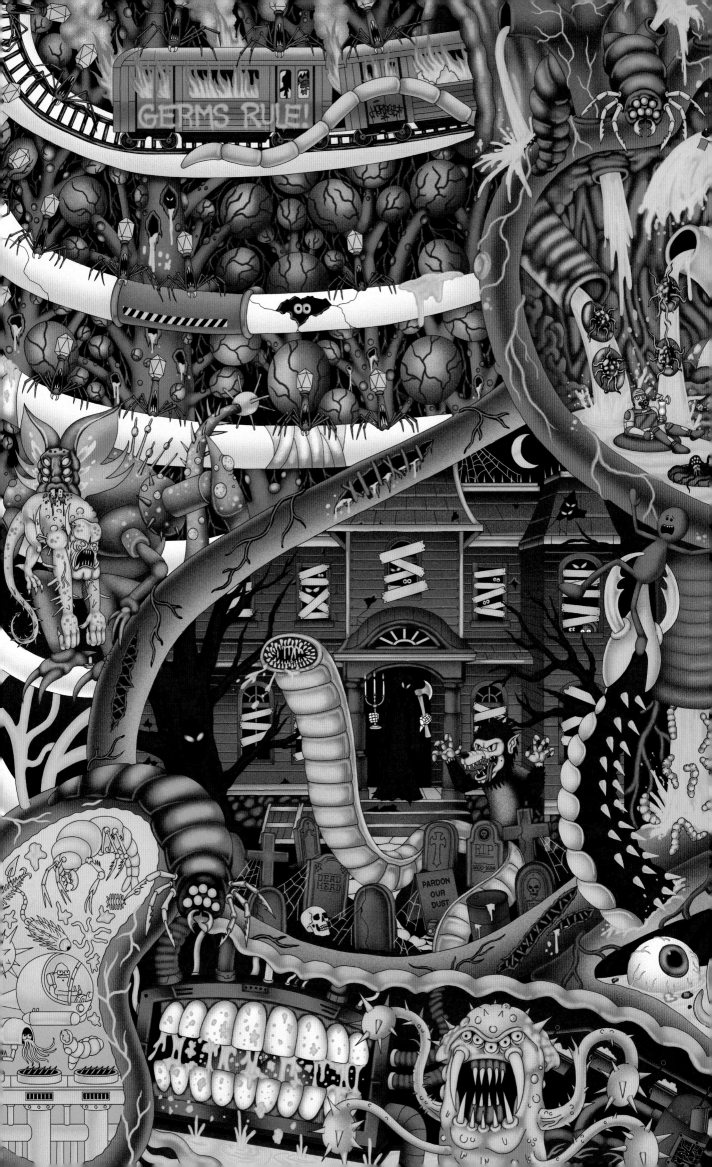

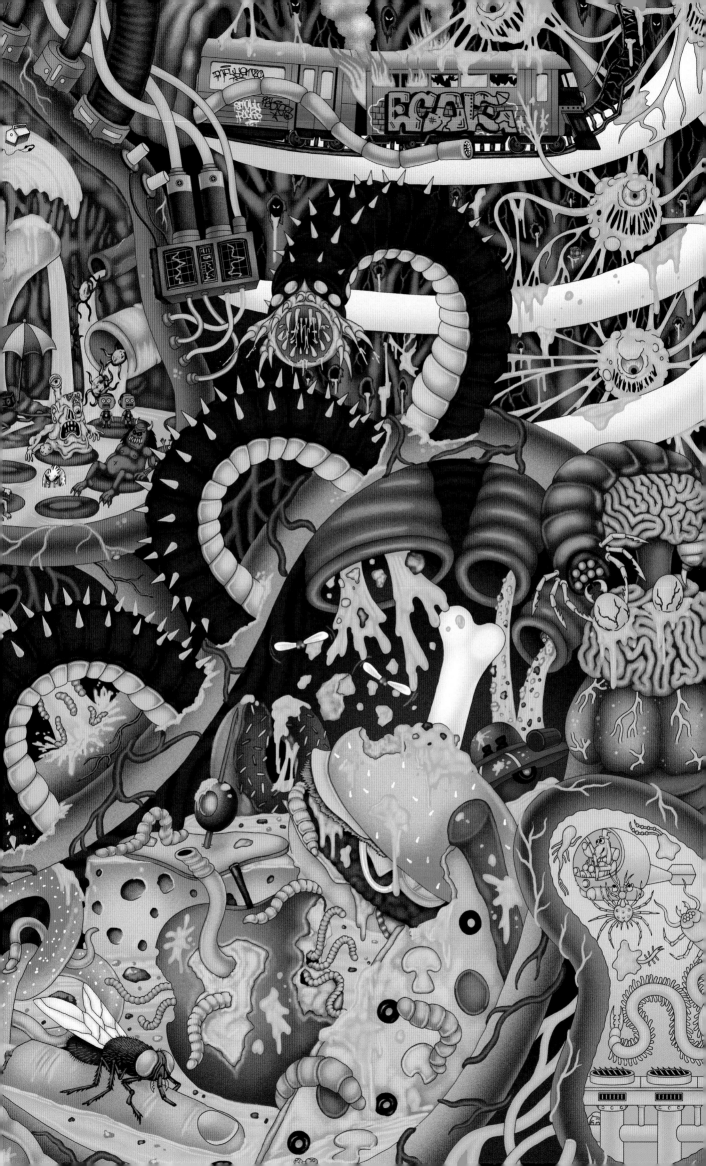

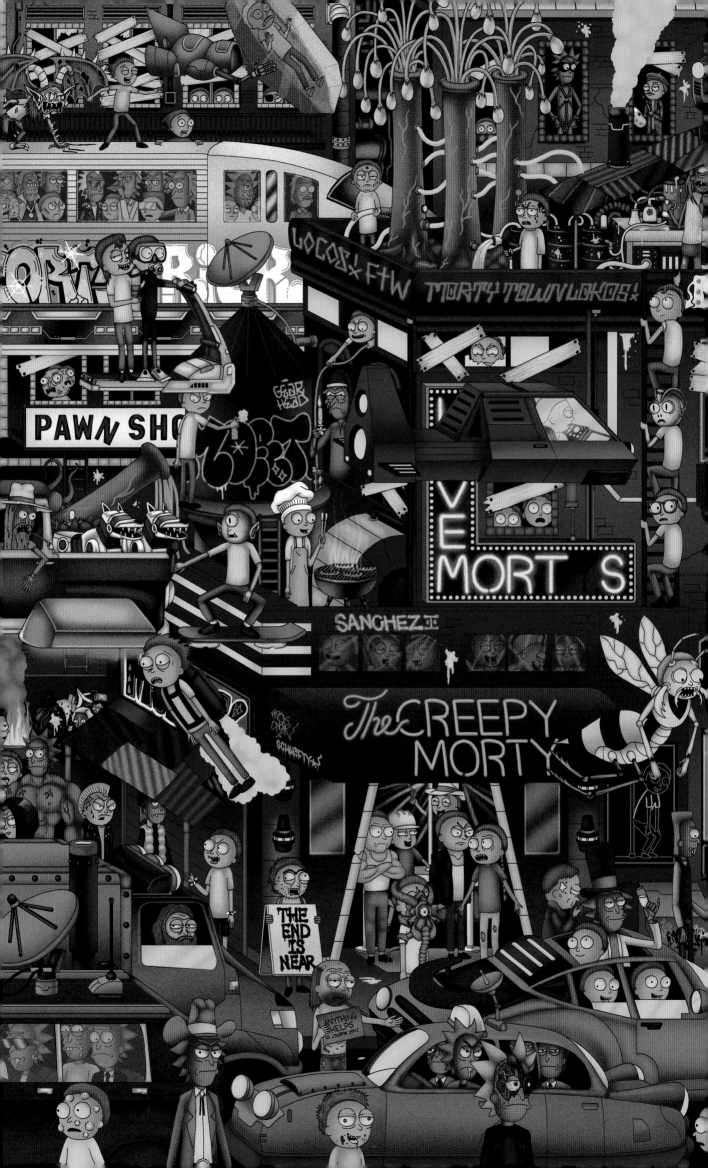

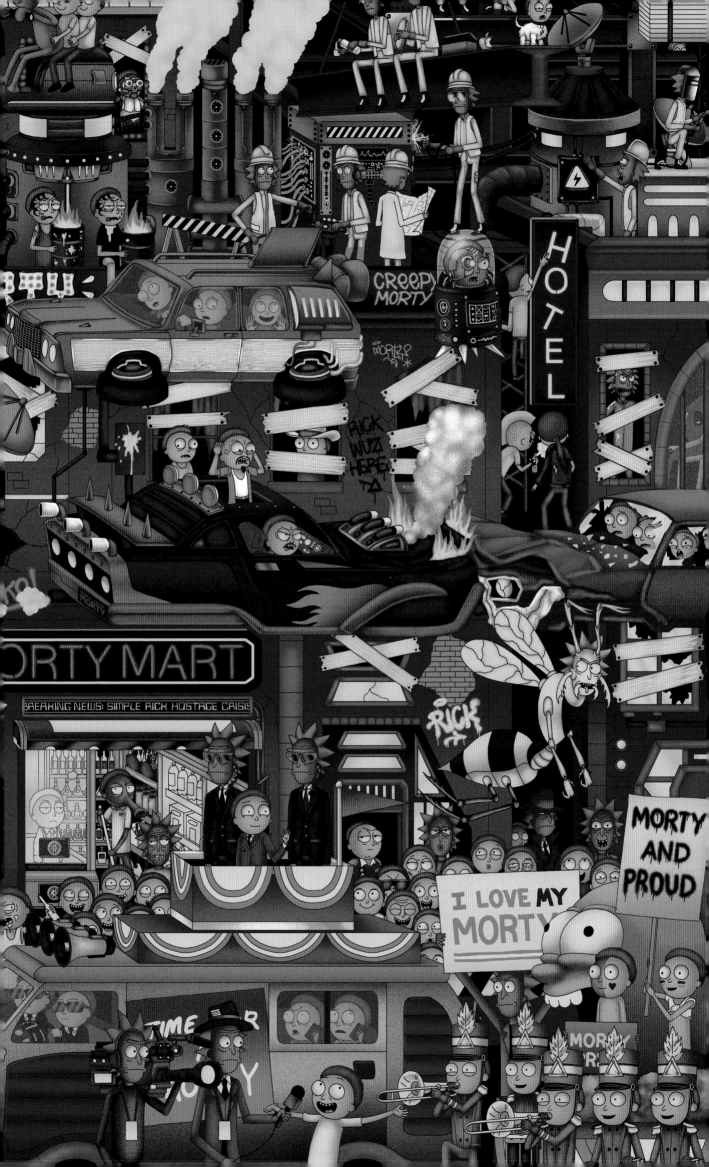

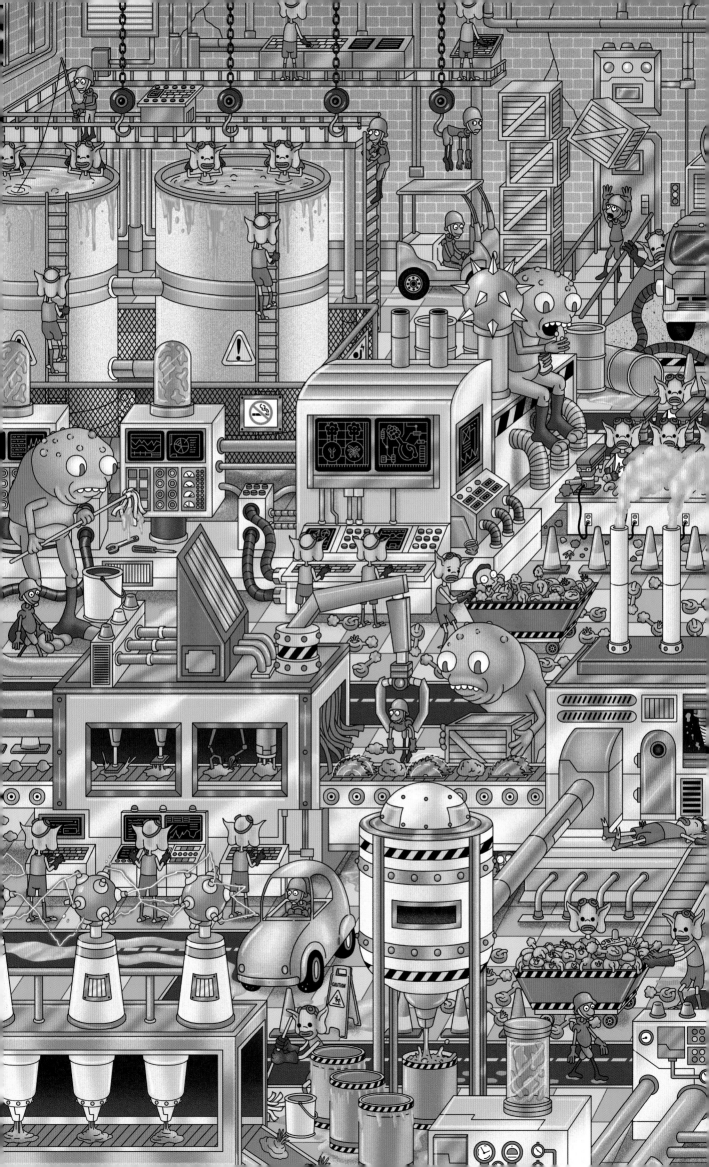

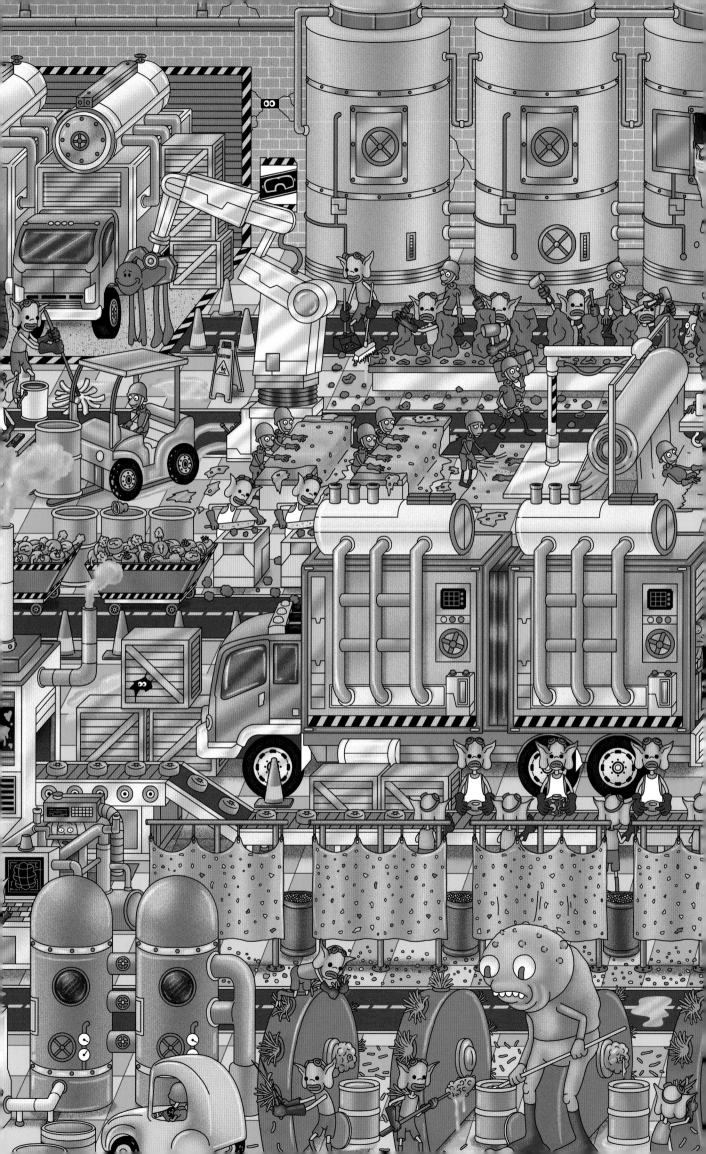

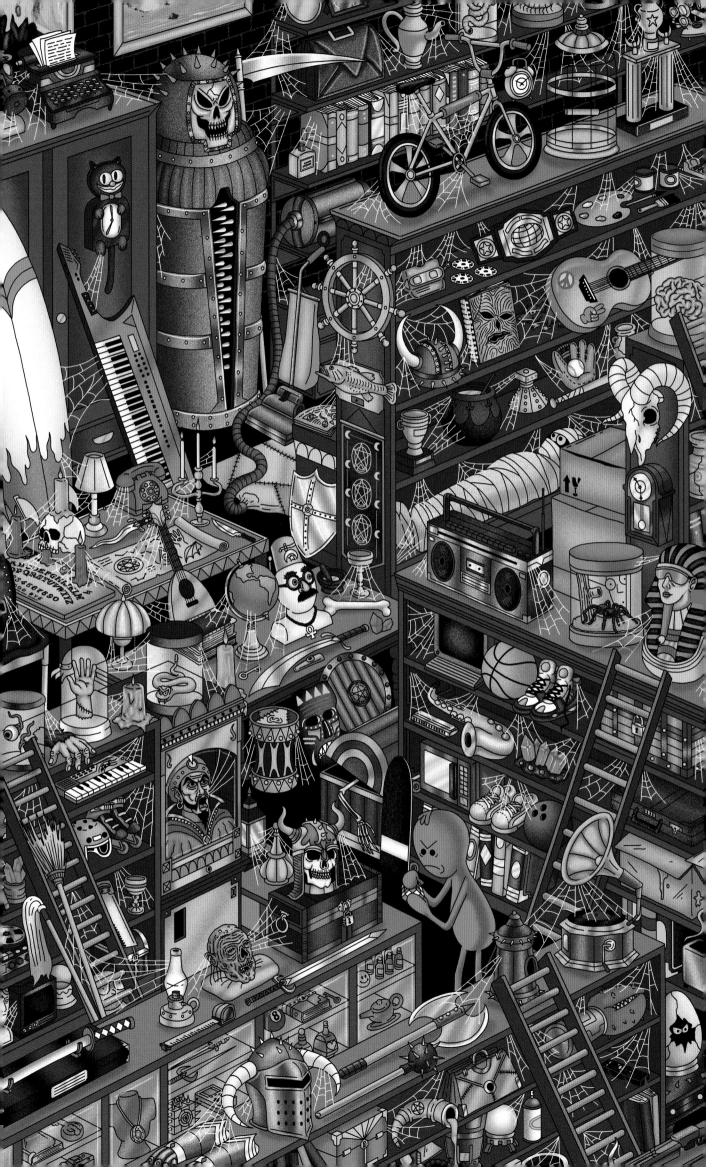

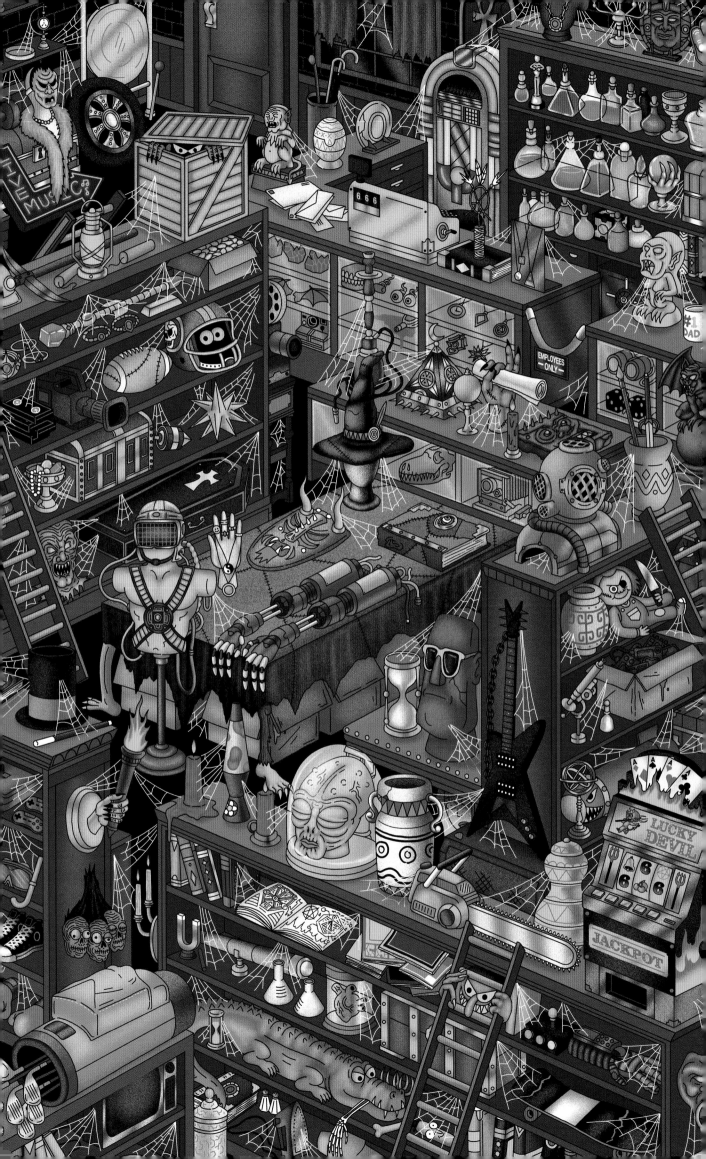

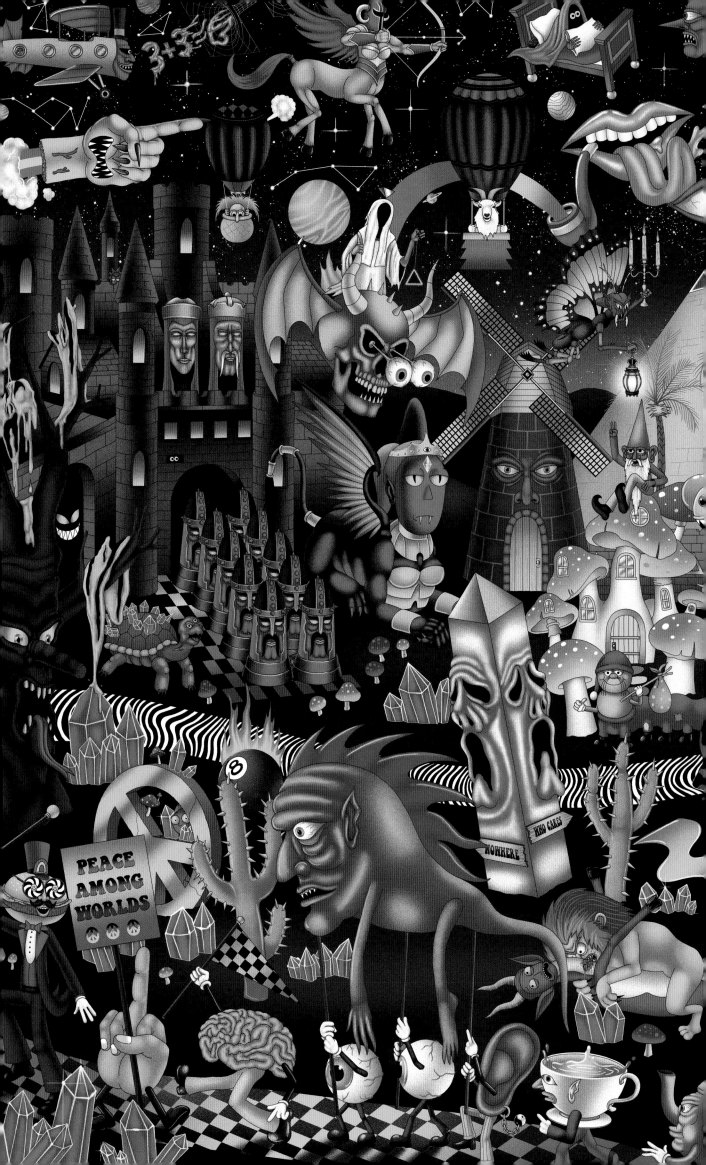

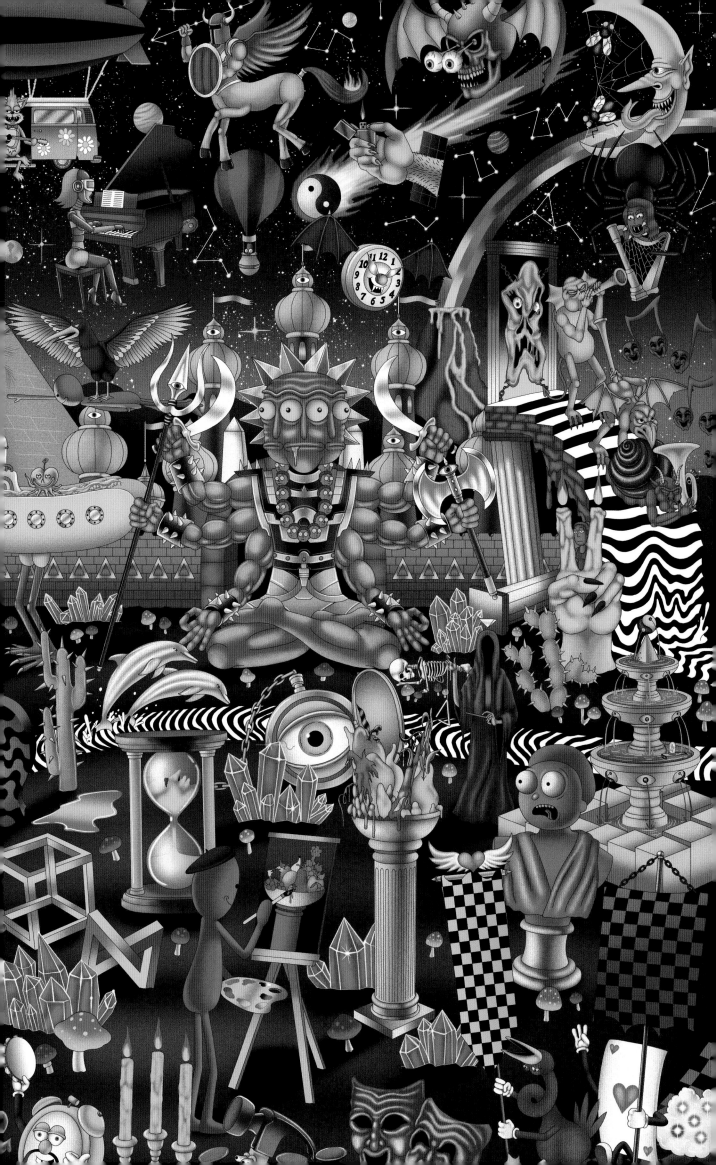

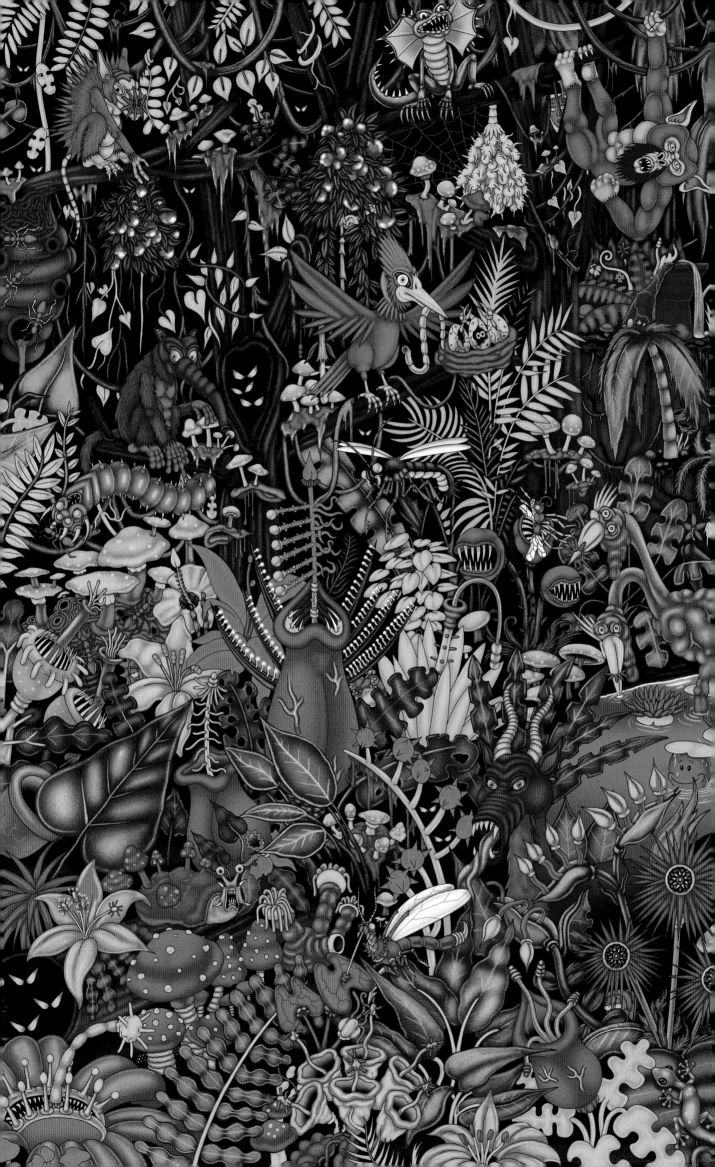

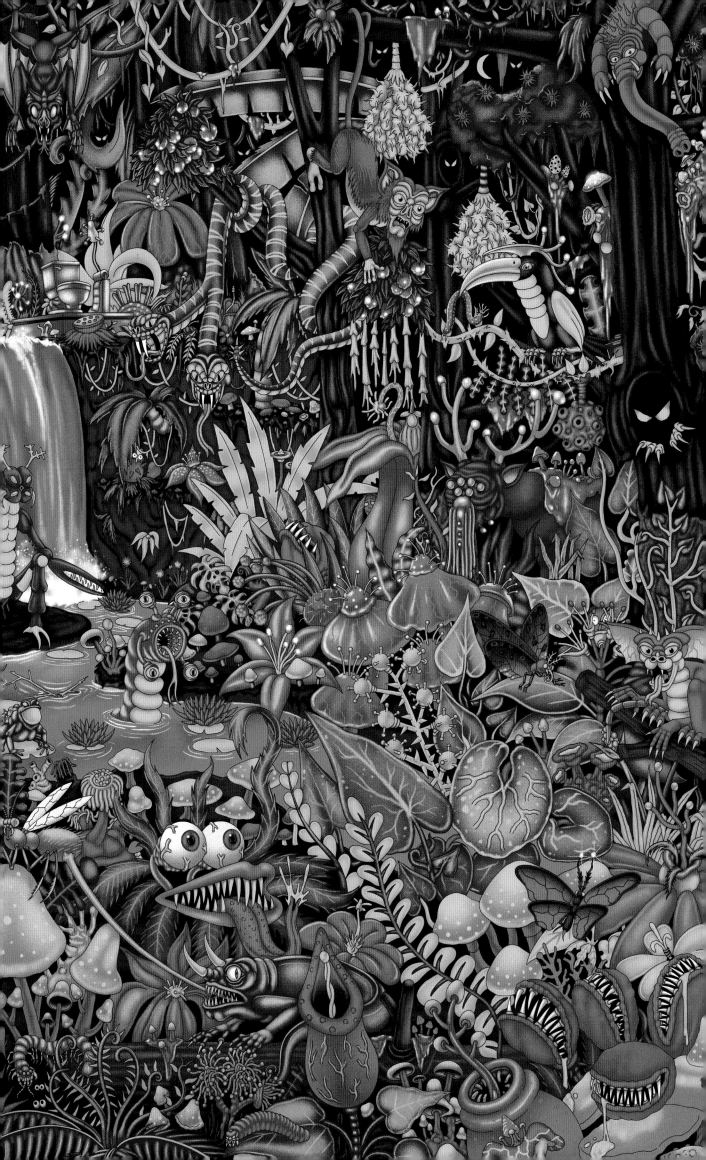

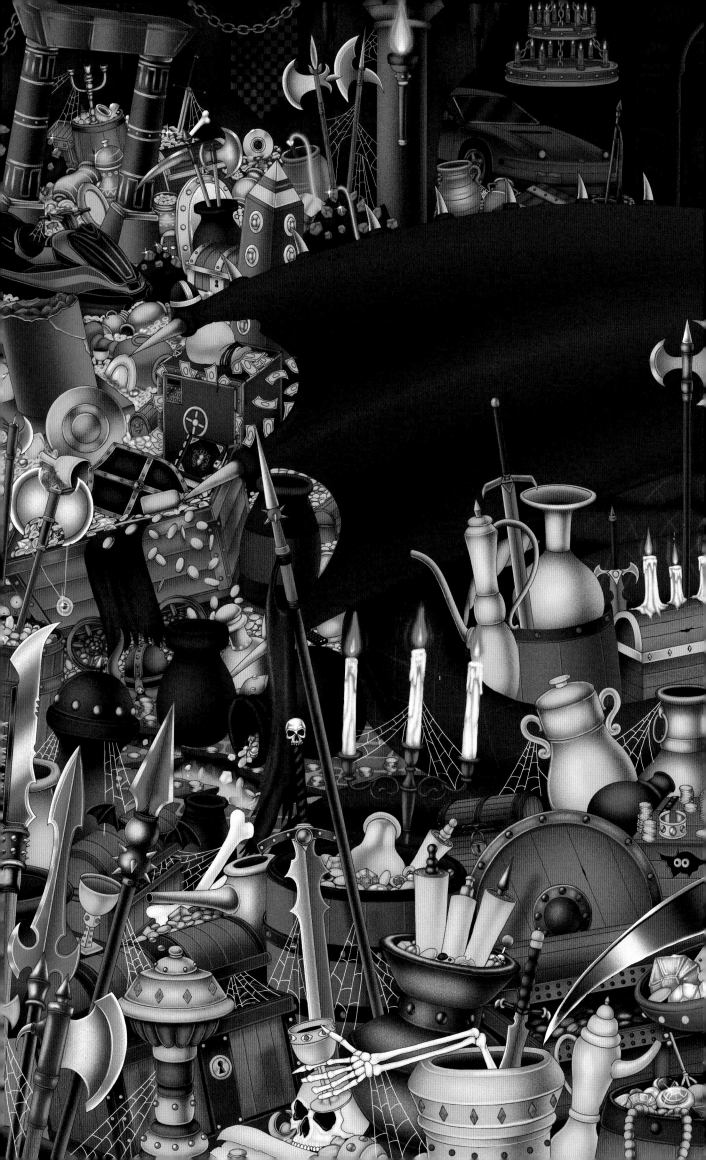

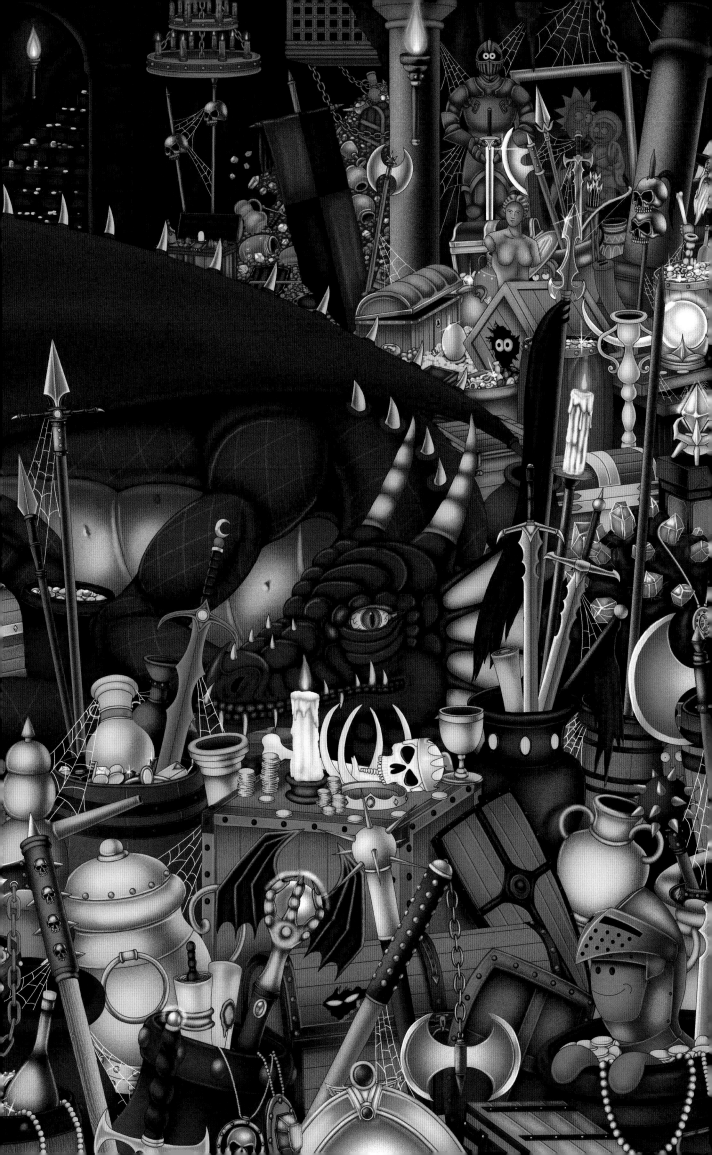

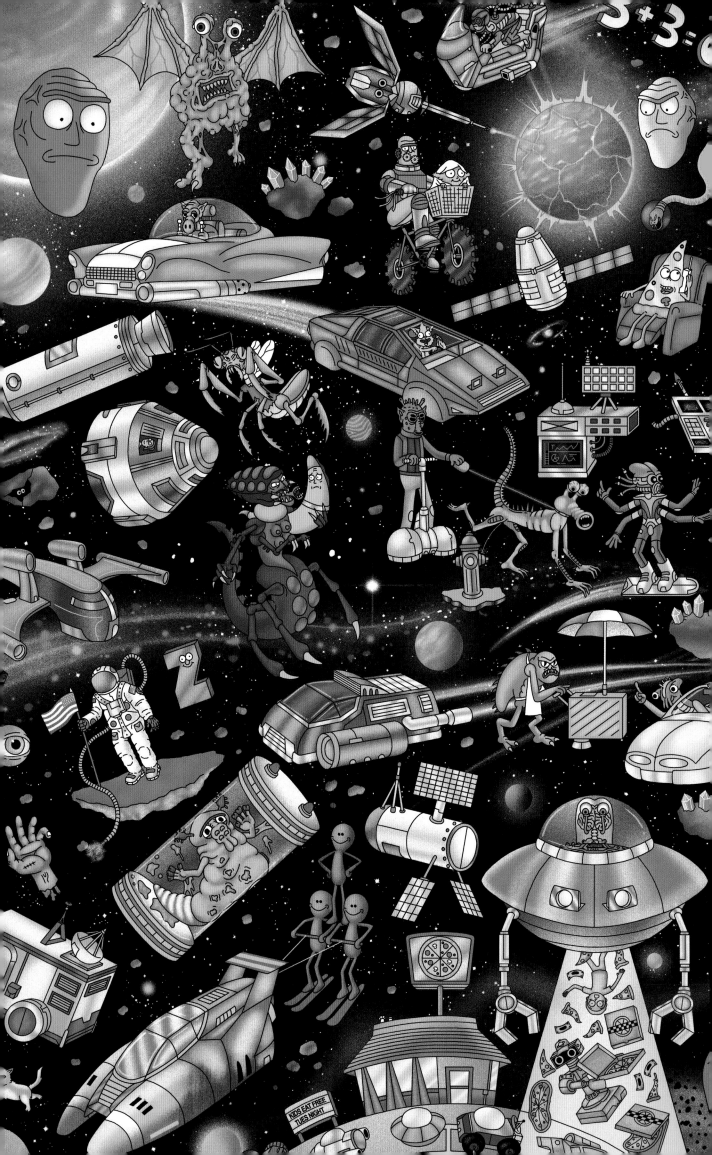

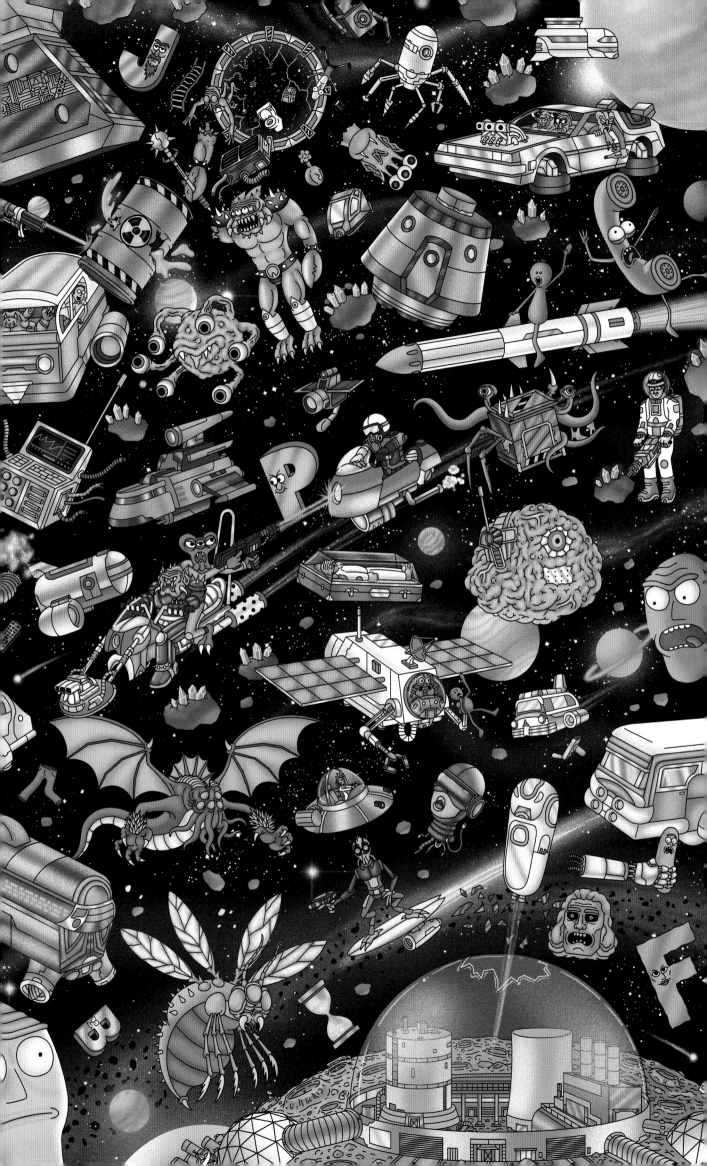

WHAT ELSE CAN YOU FIND HIDING THROUGHOUT THE MULTIVERSE?

THE SMITH HOUSE

- ☐ AMISH CYBORG
- ☐ PENCILVESTER
- ☐ REVERSE GIRAFFE
- ☐ GHOST IN A JAR
- ☐ DUCK WITH MUSCLES
- ☐ BABY WIZARD
- ☐ TINKLES
- ☐ HAMURAI
- ☐ THE MIGHTY STAFF OF RAH-GUBABA
- ☐ MR. MEESEEKS BOX
- ☐ PORTRAIT OF SNOWBALL

ANATOMY PARK

- ☐ DR. XENON BLOOM
- ☐ SWARM OF E. COLI
- ☐ ALEXANDER IN HIS DOG COSTUME
- ☐ A PAIR OF ANIMATRONIC WORKERS FROM IT'S A SMALL INTESTINE
- ☐ BUBONIC PLAGUE
- ☐ PLUMBUS

THE CITADEL

- ☐ SIMPLE RICK
- ☐ CONSTRUCTION RICKS ENJOYING LUNCH
- ☐ FIVE MEGA TREE SEEDS
- ☐ EVIL MORTY
- ☐ MR. MEESEEKS BOX
- ☐ PLUMBUS
- ☐ PORTAL GUN

PLUMBUS FACTORY

- ☐ CONTAINER OF SCHLEEM
- ☐ CRUSHED RED PARTY CUPS
- ☐ DINGLEBOP SCRAPS
- ☐ FLEEB CUTTER
- ☐ SCHLAMI ON BREAK EATING FROM A BAG OF BOBBISH
- ☐ EXHAUSTED BLAMPH WORKER
- ☐ WORKPLACE SAFETY POSTER
- ☐ ACCIDENT WITH THE SCHLEEM SMOOTHER
- ☐ UNUSED GRUMBO
- ☐ PILE OF TRIMMED CHUMBLES
- ☐ SNORKELING BLAMPH WORKER
- ☐ PORTAL GUN

NEEDFUL THINGS

- ☐ SEVERED MONKEY'S PAW
- ☐ AFTERSHAVE THAT GRANTS THE USER FEMALE ATTENTION IN RETURN FOR IMPOTENCE
- ☐ GOLDEN MICROSCOPE THAT REVEALS SECRETS BEYOND COMPREHENSION
- ☐ PAIR OF RUNNING SHOES THAT MAKE THE WEARER THE FASTEST IN THE WORLD, BUT WEARING THEM RESULTS IN RUNNING NONSTOP UNTIL DEATH
- ☐ EERILY INTELLIGENT DOLL THAT THREATENS THE OWNER (MODIFIED BY RICK TO DO TAXES)
- ☐ TYPEWRITER THAT WRITES BEST-SELLING MURDER MYSTERIES BUT EVENTUALLY MAKES THE MURDERS HAPPEN IN REAL LIFE
- ☐ FOX STOLE THAT KILLS AND SKINS THE USER
- ☐ BEAUTY CREAM THAT MAKES THE WEARER BEAUTIFUL IN EXCHANGE FOR THEIR EYESIGHT
- ☐ BOXING GLOVES THAT MAKE THE USER A BOXING CHAMPION IN 1936, TRAPPING THEM IN THE SAME MATCH FOR ETERNITY

PSYCHEDELIA

- ☐ FART
- ☐ BLACK TRIANGLE REAPER AND WHITE TRIANGLE REAPER
- ☐ FLOATING TEXT THAT SAYS "3 + 3 = 6"
- ☐ NAKED GOAT-HEAD PERSON
- ☐ POCKET WATCH WITH AN EYE INSIDE
- ☐ HOURGLASS
- ☐ ROBOT JESSICA
- ☐ MOONMAN
- ☐ ICE CREAM CONE
- ☐ AMBULATORY BRAIN
- ☐ LION RICK
- ☐ GAZELLE JERRY
- ☐ PORTAL GUN

RICK'S POOP PLANET

- ☐ TOILET
- ☐ BROKEN STICK
- ☐ CROWN
- ☐ ALIEN MOOSE
- ☐ PLUNGER PLANTS
- ☐ CRESCENT MOON
- ☐ PLUMBUS
- ☐ PORTAL GUN
- ☐ MR. MEESEEKS BOX
- ☐ TV REMOTE

BALTHROMAW'S LAIR

- ☐ TOME
- ☐ SOUL CONTRACT
- ☐ RARE VINYL
- ☐ SPINNING LOLLIPOP
- ☐ FIVE BOTTLES OF LIQUOR
- ☐ WIZARD
- ☐ SUMMER'S ARROWS
- ☐ WIZARD PORTAL
- ☐ PLUMBUS
- ☐ PORTAL GUN
- ☐ MR. MEESEEKS BOX
- ☐ TV REMOTE

OUTER SPACE

- ☐ RICK'S SPACESHIP WITH A FLAT TIRE
- ☐ SPACE SNAKE
- ☐ PANTS FOR JERRY
- ☐ ZIGERION ESCAPE POD
- ☐ PINK GAZORPIAN SPACESHIP
- ☐ SCHRÖDINGER'S CAT
- ☐ BETA 7'S HIVE SHIP
- ☐ CROMULON HEAD
- ☐ ST. GLOOPY NOOPS SPACE AMBULANCE
- ☐ SPACE BUG
- ☐ COURIER FLAP
- ☐ PICKLE RICK
- ☐ PLUMBUS

SO WHAT IF IT'S NOT CANON?! WE WORKED REAL HARD ON THIS, BRO! BE NICE ABOUT IT AT COMIC CONVENTIONS, BRO!

RICK AND MORTY CHARACTER GUIDE

In an interdimensional reality as crazy and wild as *Rick and Morty*'s, it can be hard to keep all of the characters straight, and now you don't have to use any more of your precious brain space to do it!

Learn all about your favorite (and not so favorite) characters from the hit show, the humans and the aliens, with the *Rick and Morty Character Guide*.

Collecting information on the whole cast of characters, this book is a must-have for any fan of the award-winning Adult Swim show!

$39.99 US | ISBN 978-1-50671-690-9

™ AND © 2023 CARTOON NETWORK

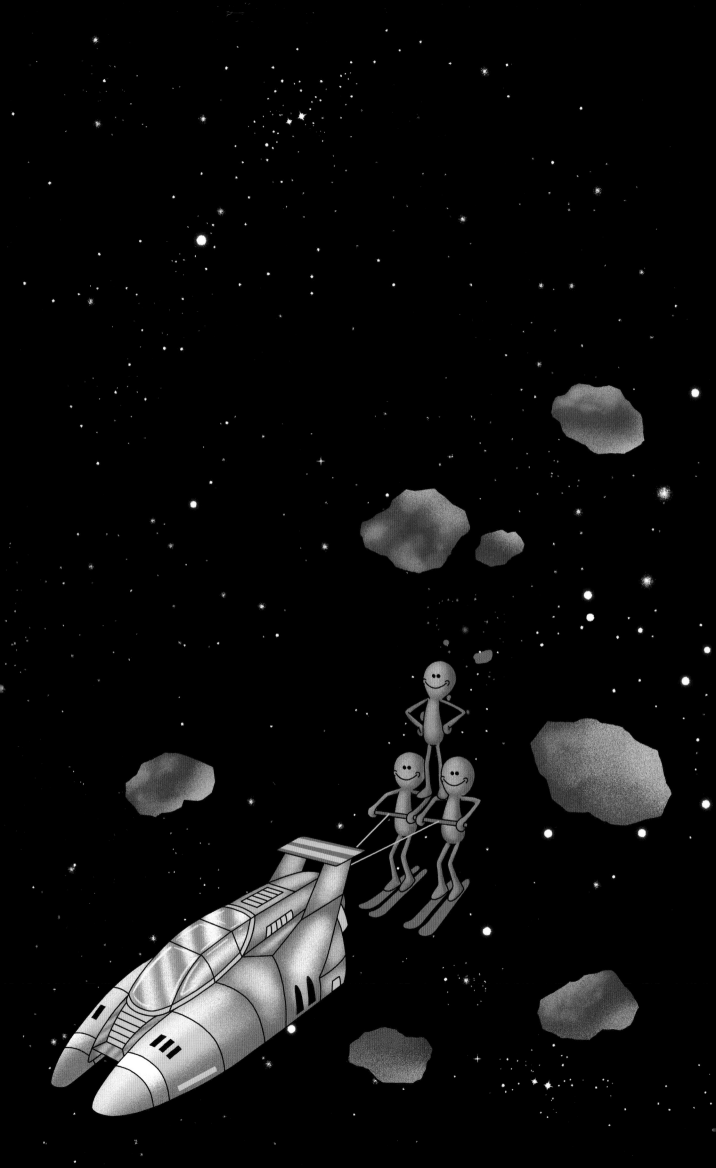